AVIE'S DREAMS

AVIE'S

# DREAMS

AN AFRO-FEMINIST COLORING BOOK by MAKEDA LEWIS

FEMINIST
PRESS
AT THE CITY UNIVERSITY
OF NEW YORK
NEW YORK CITY

Published in 2016 by the Feminist Press
at the City University of New York
The Graduate Center
365 Fifth Avenue, Suite 5406
New York, NY 10016

feministpress.org

First Feminist Press edition 2016

This book was made possible thanks to a grant from New York State Council
on the Arts with the support of Governor Andrew Cuomo and the New York
State Legislature.

First printing September 2016

Illustrations and design by Makeda Lewis
Cover design by Drew Stevens
Production by Suki Boynton

For the three women I share blood, life
and, occasionally, candied yams with.
For Myles, Michel'le, Philip, and Andrei.
For Arielle, my perfect brown babygirl.

For you, brown and freaky and queer
and still here.
You are more and you are enough.

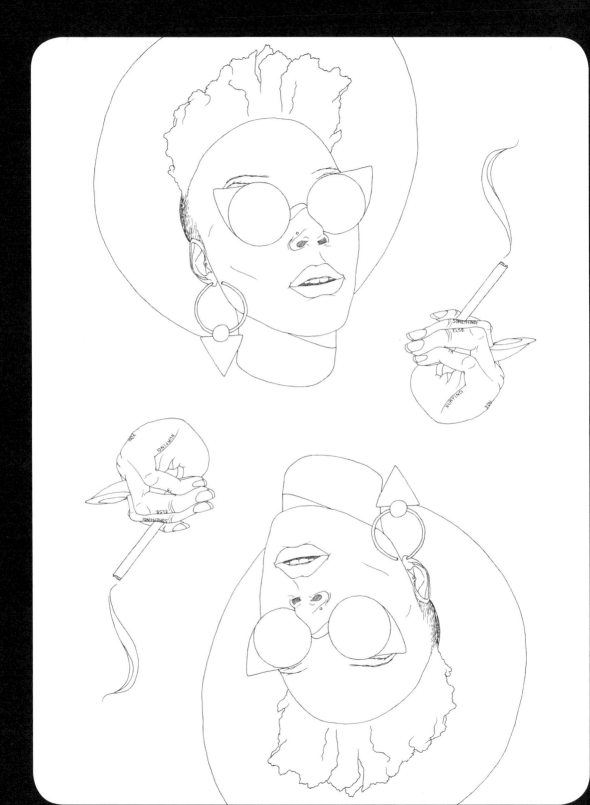

The smoke drowned out the rejection.
Do you have a lighter I can borrow?

Coming to a place where you feel like everything you've been taught is an elaborate scheme, a lie, it's very painful. Everything about what's wrong or right, what's pretty or ugly, what makes you worthy, the importance of money . . . But breaking down is also breaking open. You are open to a new plane of freedom once you let the masks go.

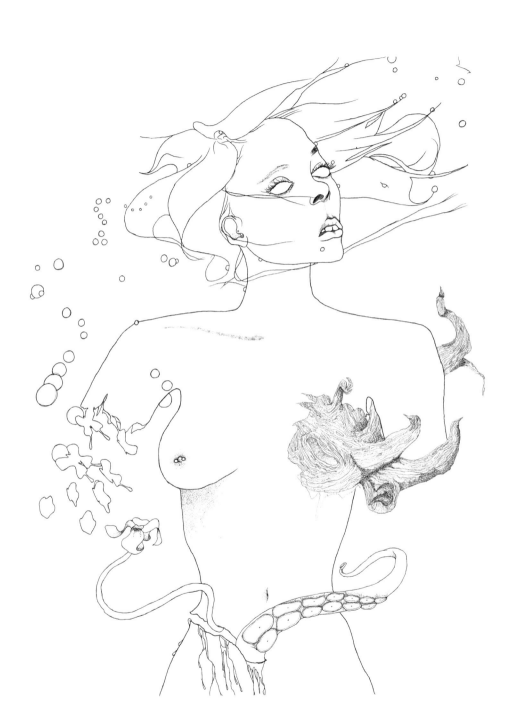

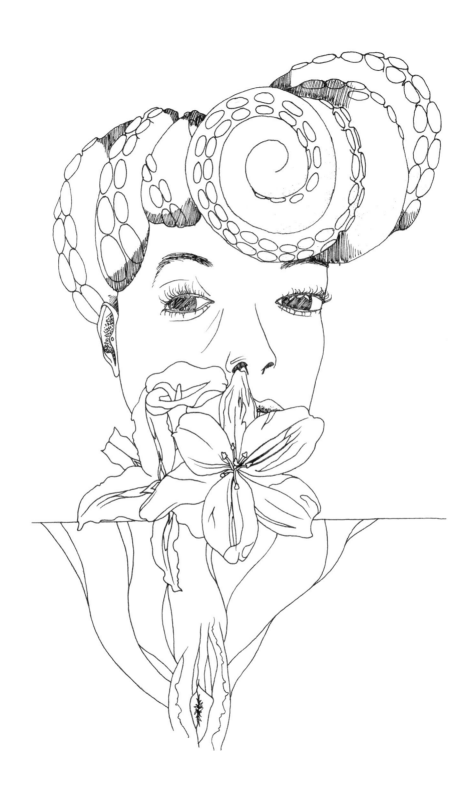

The vagina is a highly perceptive part of the body, just like any other. Negative thoughts and actions expressed towards the vagina can have an effect on the creativity, confidence, self-image, and self-esteem of persons with vaginas.

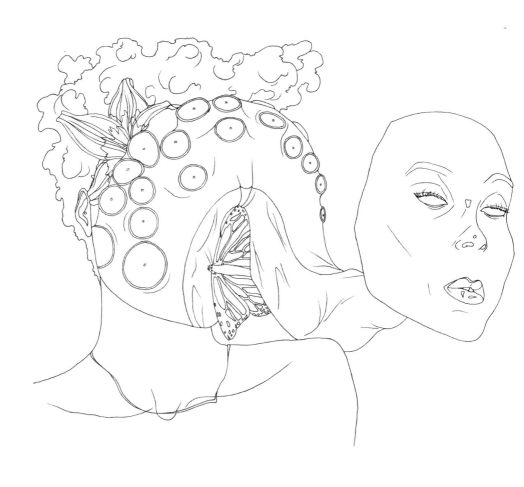

Everything in existence follows a life-death-life cycle. It is important to know that "beginning" or "end" are signifiers of the moment one starts to pay attention to the cycle.

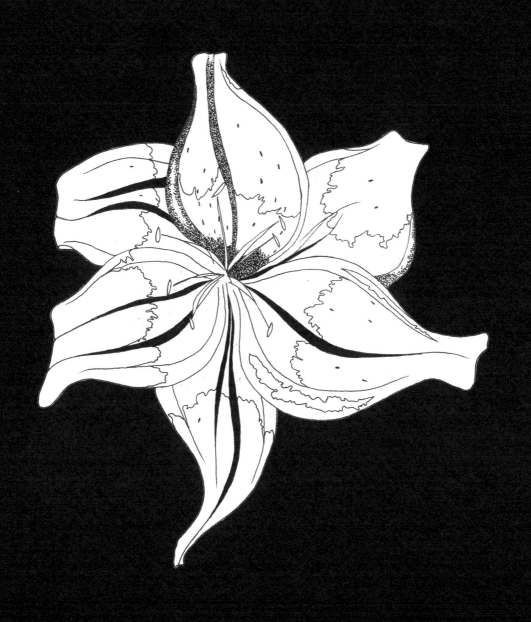

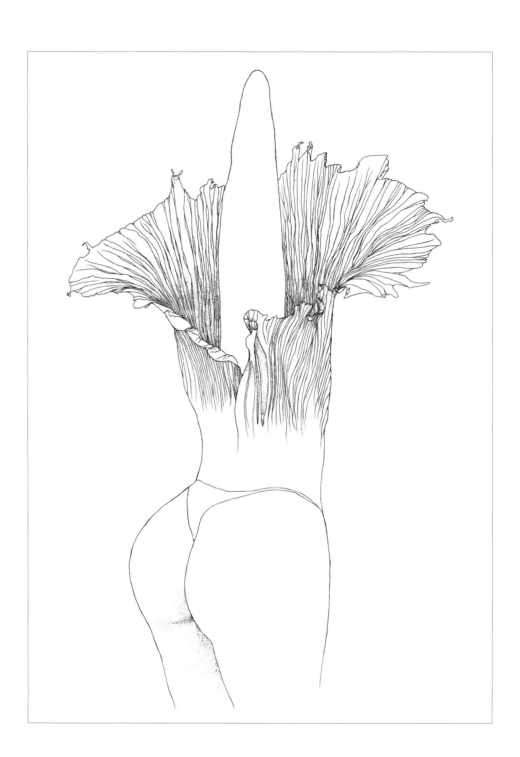

Life, death . . .

I have become accustomed to playing games with the time I have on this earth. I treat my body as if I have a redo button in my purse. I'm constantly wondering what it is that I really want. Do I want to treat my body as if it's the magical machine it is? Or would I rather drown in indulgence and call it fun?

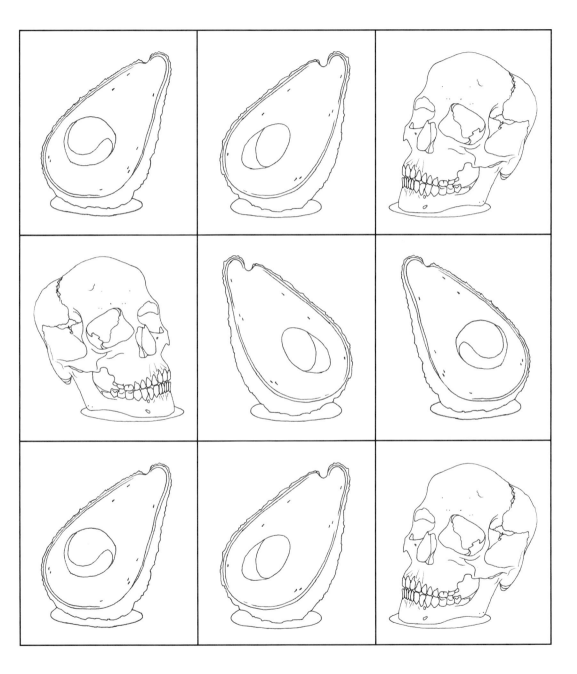

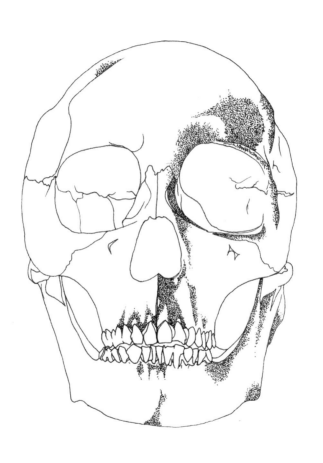

Sometimes we are lucky enough to meet people who not only keep us grounded through these papier-mâché projects we call lives, but they remind us of our inherent worth and power. Following your heart doesn't have to be tragic or irrational. Thank these people for getting us through the machine.

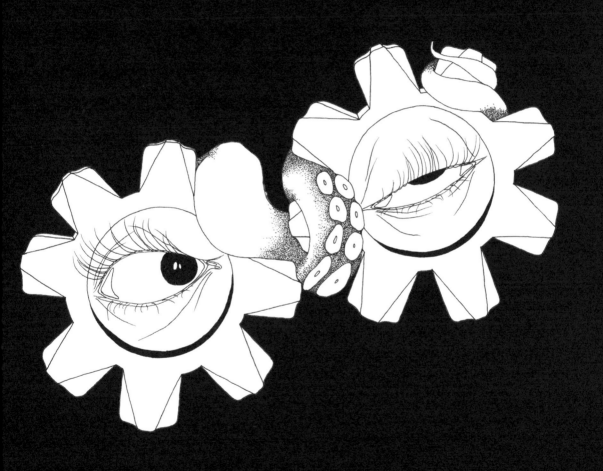

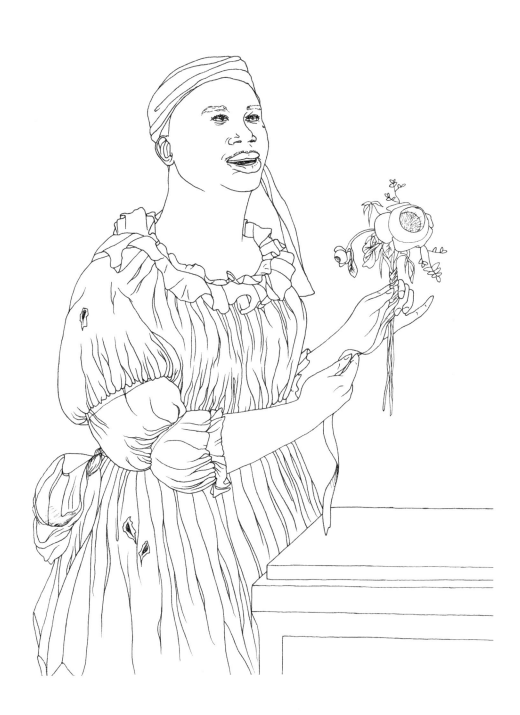

Blackness is not monolithic and does not need to accept subjugation and suffocation in order to be respected.

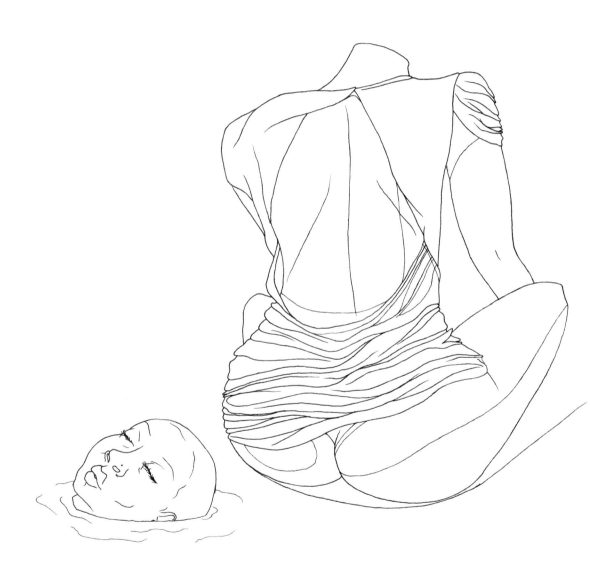

Sankofa.

The intersection of my femininity and blackness is fascinating. I carry so many colors in my skin, so much weight in my hips, infinite voices in my throat. How could I not love myself?

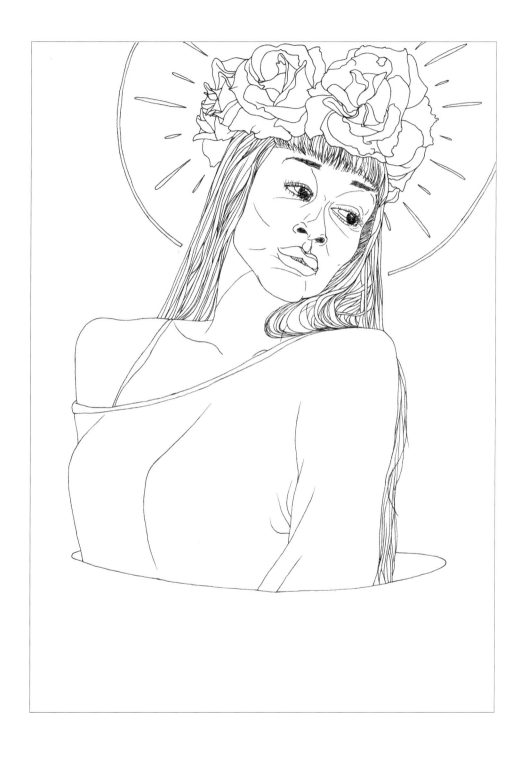

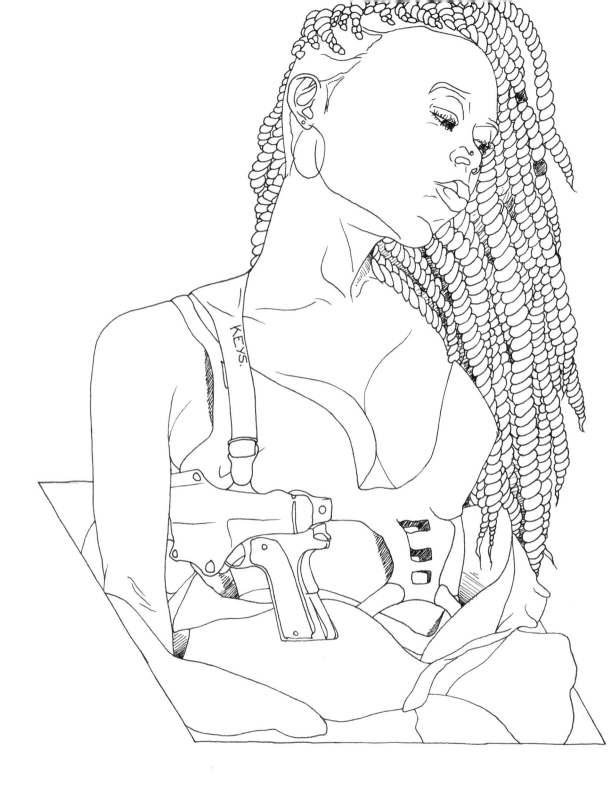

I grow older and slowly shed the things that have been weighing me down. I notice building my inner peace, a part of me that's sacred and reassuring, requires that I learn how to protect myself.

Sure, some people would gladly take energy from me and leave only debris in return. But mostly, my biggest threat is what's in my head.

I reject the idea that I am defined by my biology.

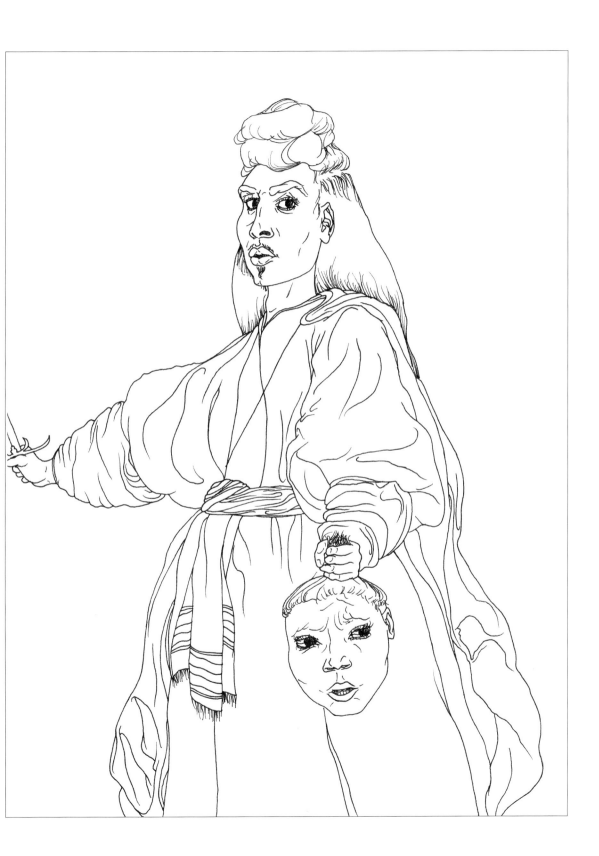

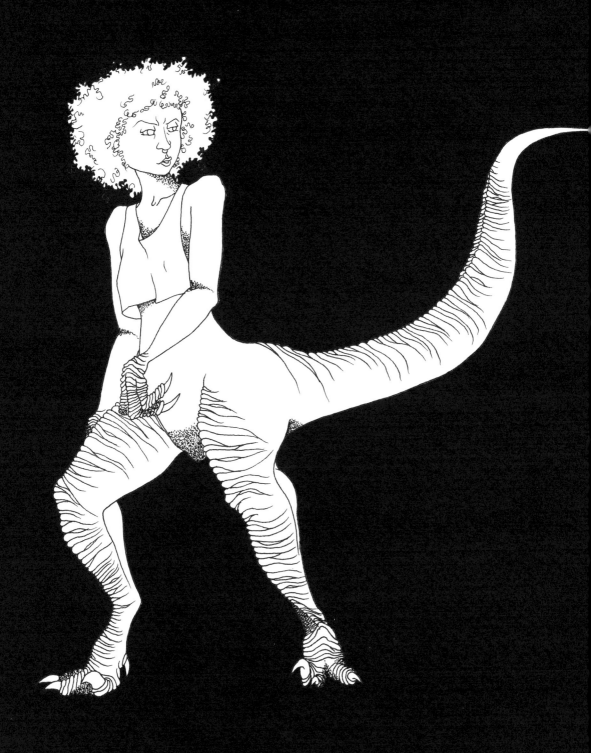

It's monstrous and empowering to see the type of creature I become when I fight for something I believe in.

My confidence to move in life is sustained by the women before me, feeling them laugh and cry through salt-water tongues as they roll in my blood.

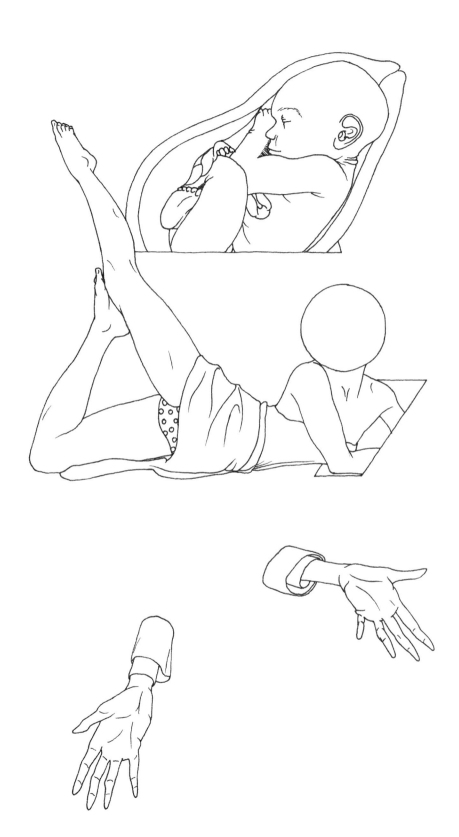

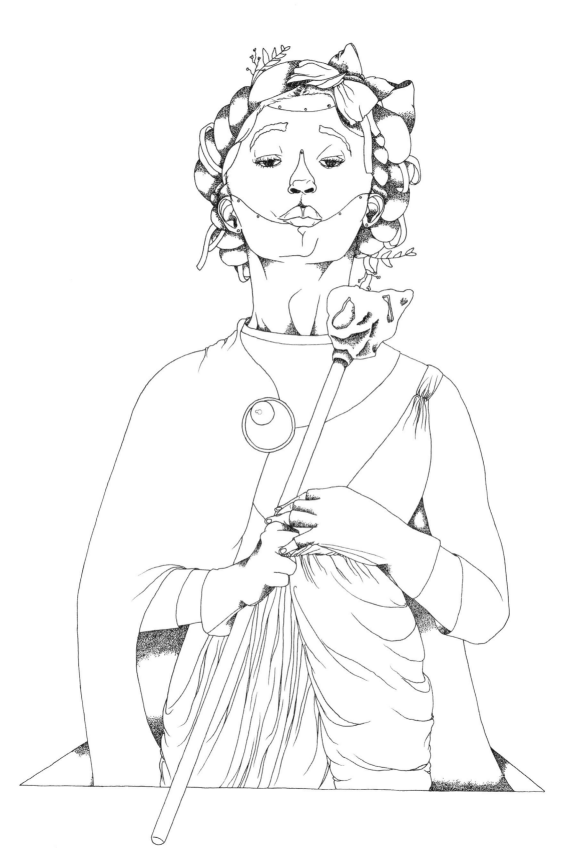

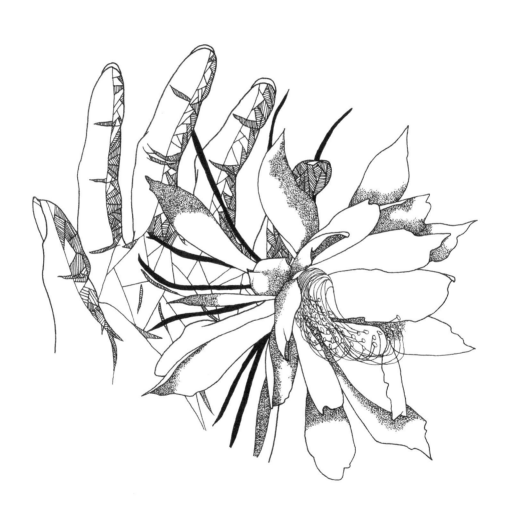

The night-blooming cereus only flowers at night. It's fascinating how many things in nature speak to us about human life. Many of us may find our petals opening in the dark.

The season of acknowledging what in you must die so other things can live can be uncomfortable, but the rebirth is worth it.

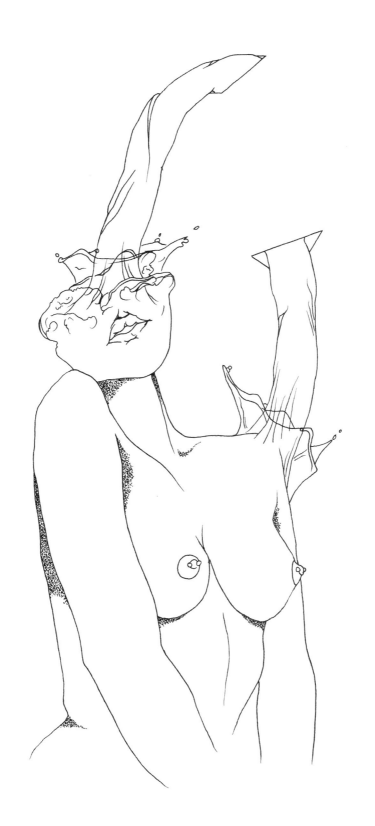

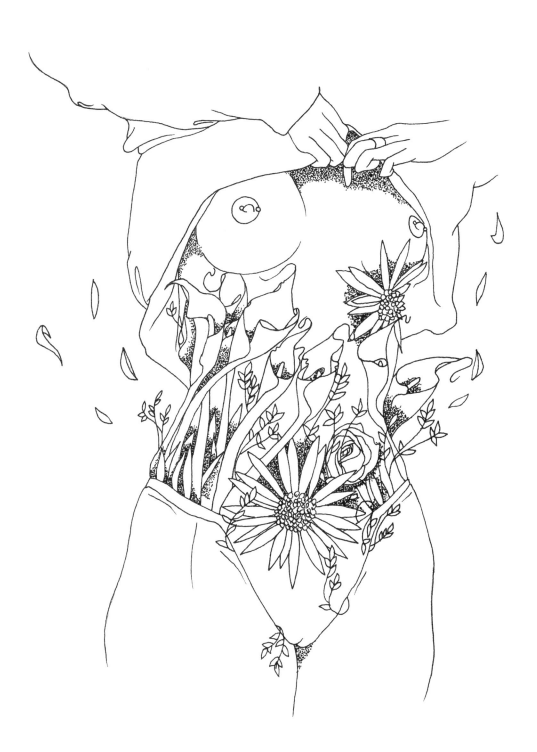

There are places on and in me where all I used to see were inadequacies and scars. Now it seems like every time I look, there's a rose petal where I used to see ugliness.

For the first time in my life, I'm in love. I'm highly suspicious that she may be an alchemist, because when I look at my reflection in her eyes, all I see is gold.

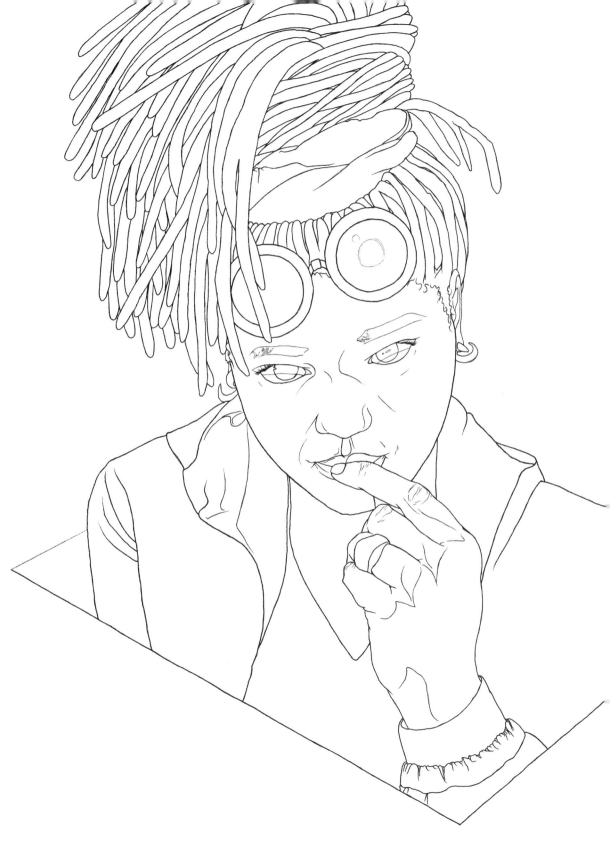

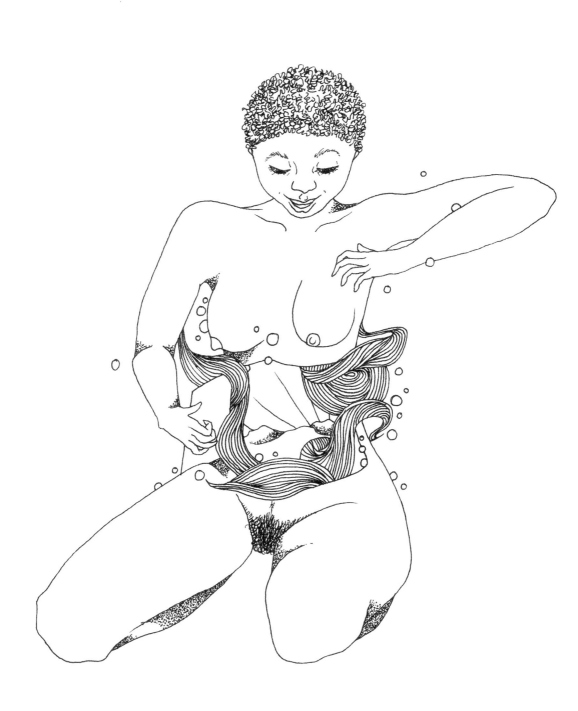

"What have you done to me?"

"Love you, that's all."

The worth of a woman, her preciousness, is not measured by how many men haven't touched her, the clothes she has on, how much she cusses—or how still she sits on a pedestal built by people who conflate womanhood with "servant."

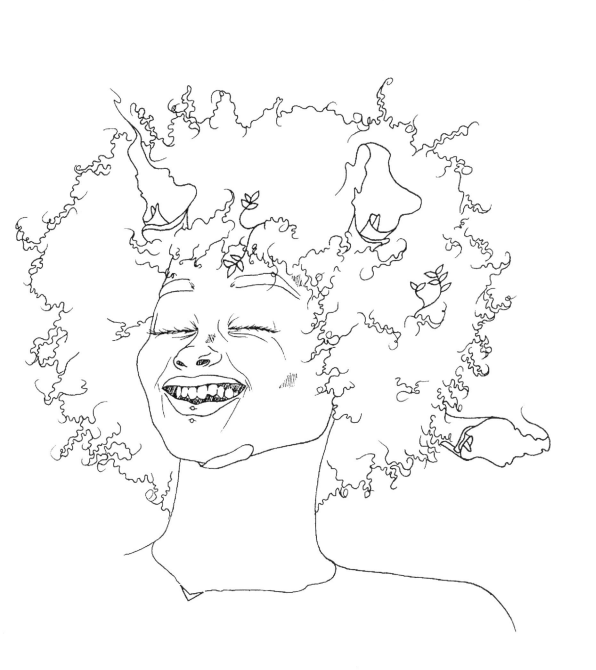

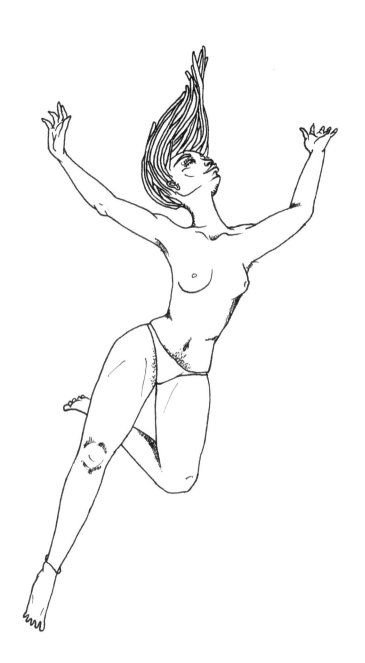

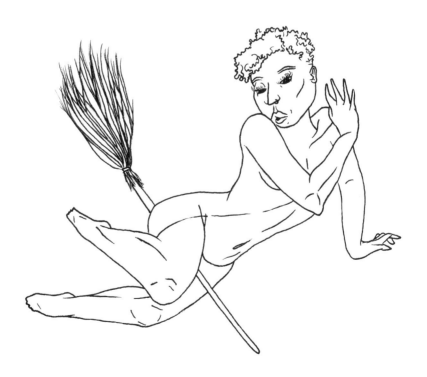

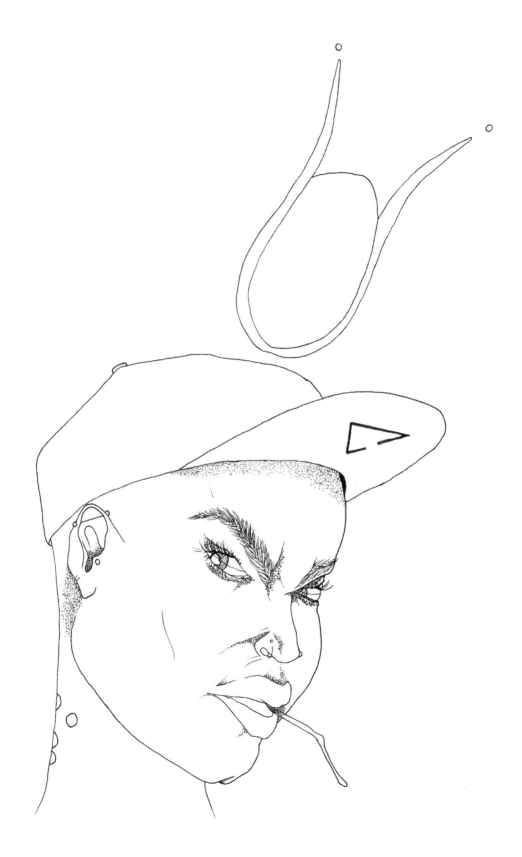

I am the master of my fate.

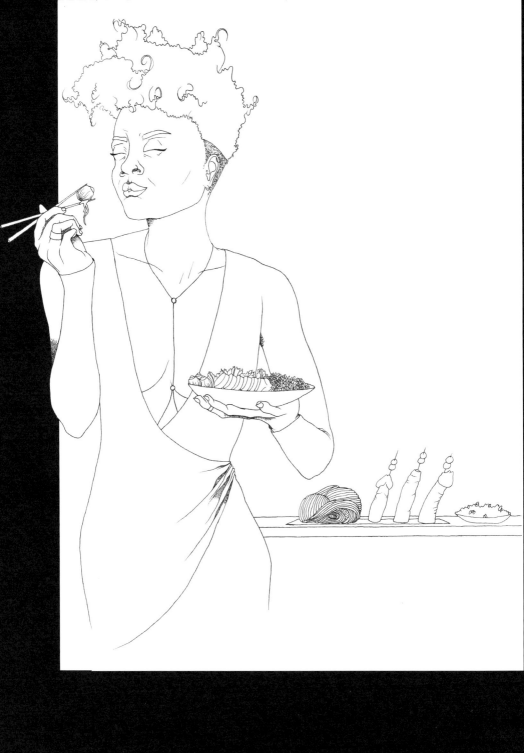

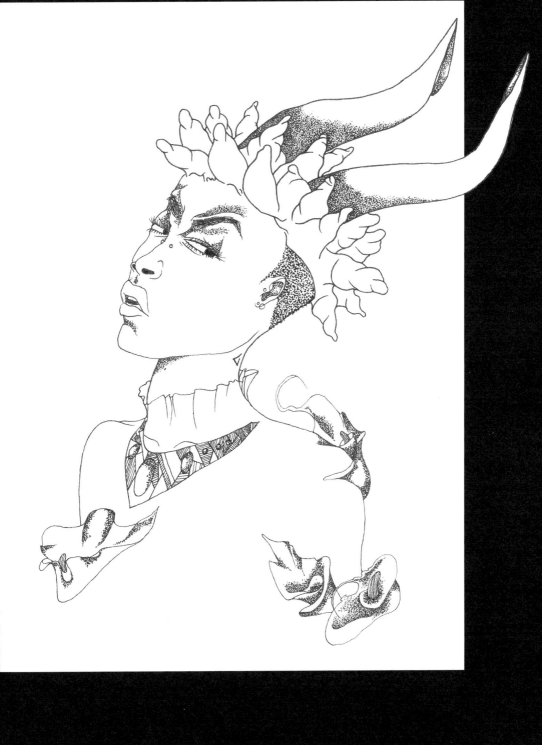

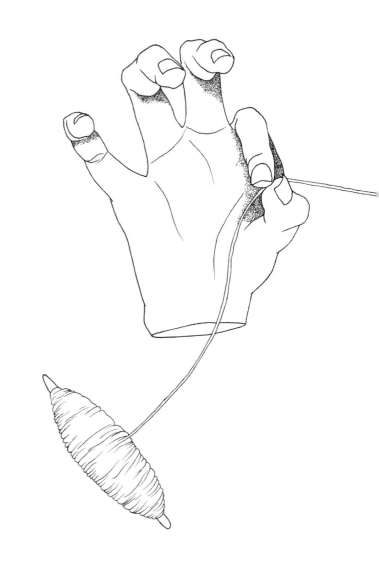

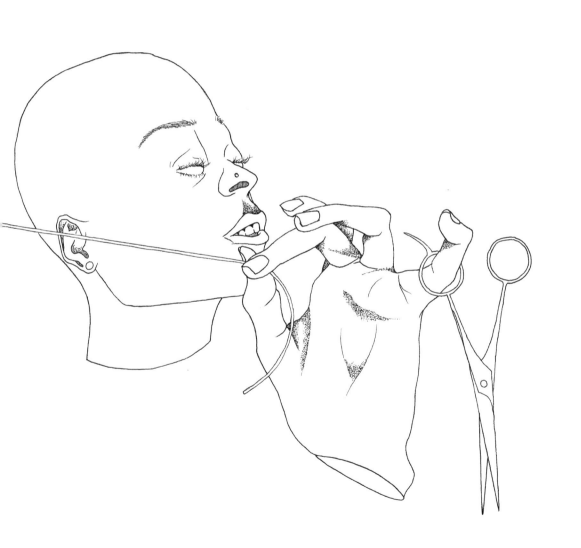

The resilience and evolution of black women is nothing short of futuristic and all-encompassing. We are the soil and the flowers, the map and the destination, the hovercraft and the pilot.

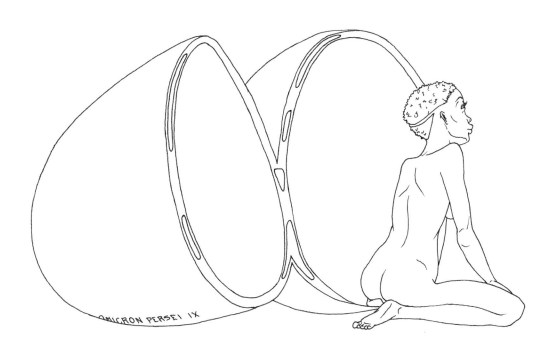

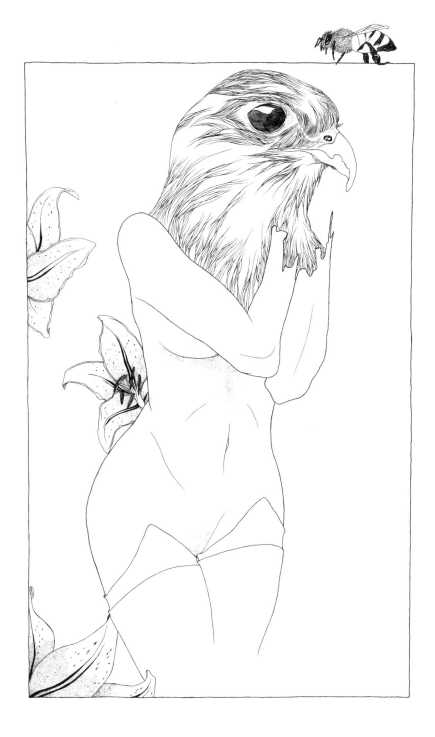

I don't worry about the bad shit I've done in the past. I have the same potential as anyone to be peaceful and giving, beautiful and true. I contain monsters and angels. I'm not scared of that.

The Feminist Press is a nonprofit educational organization founded to amplify feminist voices. FP publishes classic and new writing from around the world, creates cutting-edge programs, and elevates silenced and marginalized voices in order to support personal transformation and social justice for all people.

See our complete list of books at
**feministpress.org**